Vincent van Gogh

A Biography by **ELIZABETH RIPLEY**

Vincent

Published by Oxford University Press

van Gogh

With Drawings and Paintings
by Vincent van Gogh

HENRY Z. WALCK, INC., Distributors

ILLUSTRATIONS

In the gray light of dawn a group of coal miners trudged along a snow-covered path on their way to work. At the entrance to the mine sat a young man with a red beard and ragged clothes. He held a pencil and sketchbook and he sketched the weary men and women as they passed by. The man's name was Vincent van Gogh. For two years he had worked as a missionary in the mining country of Belgium. He gave the workers his clothes, his money and his food. He took care of the sick and injured. His bed was the bare floor of a wooden hut. He even smeared his face with coal dust so that he looked like a worker. The miners loved him and called him the "Christman."

Vincent was the son of a minister in a small town in Holland. When he was sixteen he had been given a job in an art gallery belonging to his rich uncle, Vincent. The boy worked hard and learned a great deal about pictures. Four years later he was sent to the London branch of the company.

"It is such a fine business," Vincent wrote enthusiastically to his younger brother Theo, who had just started to work in his uncle's firm.

Vincent loved pictures, but he didn't know how to get along with people. His crude manners frightened customers in the shop. He would argue with them, spitting out his words in a disorderly fashion. Finally his uncle decided to dismiss him from the company.

Vincent found a job teaching in a boys' school near London. In his free time he studied the Bible and read religious books. He became fired with the desire to be a preacher. When school was over he went back to his home in Holland and told his parents that he wanted to study for the ministry.

He plunged into his work with zeal, but after fifteen months of furious study he failed the examinations. Vincent still had a great longing to help the poor and needy; so, in the winter of 1878, he asked to be sent as a missionary without pay to the grim coal-mining country in Belgium.

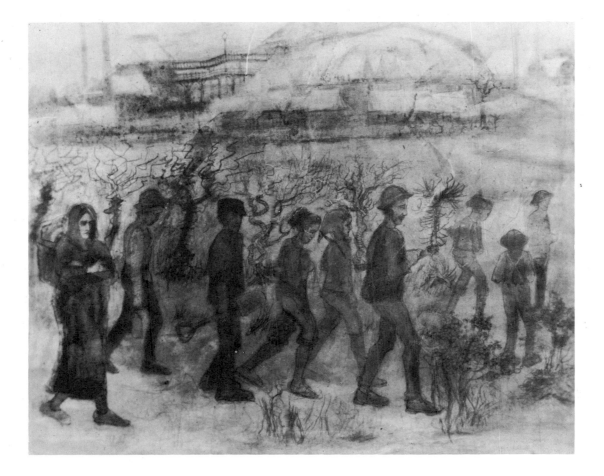

MINERS GOING TO WORK 1880
Collection State Museum Kröller-Müller, Otterlo, Holland

For two years Vincent prayed and preached and cared for the unfortunate miners. In the suffocating blackness of the coal pits he saw men working twelve hours a day to earn enough money to buy bread for their families. When the workers struck for more pay, Vincent took their side. A fire broke out in the mine, and he dressed the wounds of the injured and sat by the bedsides of the dying.

One day a committee of missionaries from the city of Brussels visited Vincent. They found him dressed in rags, living in a squalid miner's hut. When they ordered him to live in a more dignified manner, Vincent stubbornly refused. In a few days word came from Brussels that he had been dismissed.

Vincent did not dare to go home, because he felt he had disgraced his parents. For weeks he wandered barefoot through the country. At night he slept on the ground under the stars. He drew pictures of the miners and tried to exchange his sketches for crusts of bread. He described his sufferings in long letters to his brother Theo. Sometimes he enclosed sketches. Theo was moved by the depth of feeling expressed in his brother's crude drawings and urged him to send more. Suddenly Vincent knew that he must become an artist. He was then twenty-seven years old.

"I am in a rage of work," he wrote Theo. He sketched dingy miner's huts, black cold dumps and stark chimneys. He drew a group of women staggering under the weight of the coal sacks they carried on their backs. In his drawings he tried to tell people of the miseries of the Belgian miners. "If only I could succeed someday in learning to draw well what I want to express," he wrote.

From Paris, Theo sent him pictures to copy and books to read. Then one day he sent money which he had saved from his salary. He wanted his brother to go to the city and study drawing.

In the fall of 1880 a haggard and shabby Vincent arrived in Brussels. With Theo's money he bought pencils and sketchbooks. He rented a small garret room and there in a frenzy of enthusiasm he began to draw.

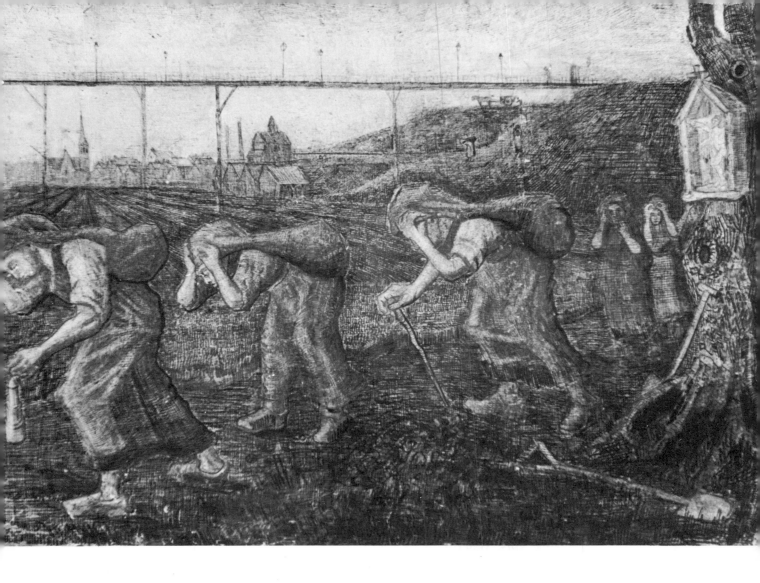

THE BEARERS OF THE BURDEN 1880

Collection State Museum Kröller-Müller, Otterlo, Holland

Vincent was too poor to study at the fine art school in Brussels, but he met an artist who taught him some rules of perspective and loaned him books on anatomy. Through the cold dark winter he worked alone in his garret room. For days he ate only bread and chestnuts. He felt sick and lonely. When spring came he wrote his parents, who were living in the village of Etten, that he was coming home.

"I am so glad that things have been arranged that I can stay and work here in peace," Vincent wrote from Etten. Early each morning he left the house and returned at sunset with a sketchbook filled with drawings. Over and over he drew peasants working in the fields and laborers in their cottages. Many of the figures were poorly drawn, and his parents thought they were very ugly. Would their son ever sell his sketches they wondered. Vincent paid no attention to his mother's suggestion that he paint portraits of the pretty girls of Etten, for he was not interested in making pictures which would sell.

It was difficult for Vincent's parents to understand their son's strange behavior. His clothes were ragged, his red hair and beard untidy, and he answered the neighbors rudely when they spoke to him. He argued continually with his father about religion.

On Christmas Day he refused to go to church. In a burst of rage he told his father that he thought the whole system of religion was "horrible." Life with his parents had become unendurable. The next day he left Etten forever.

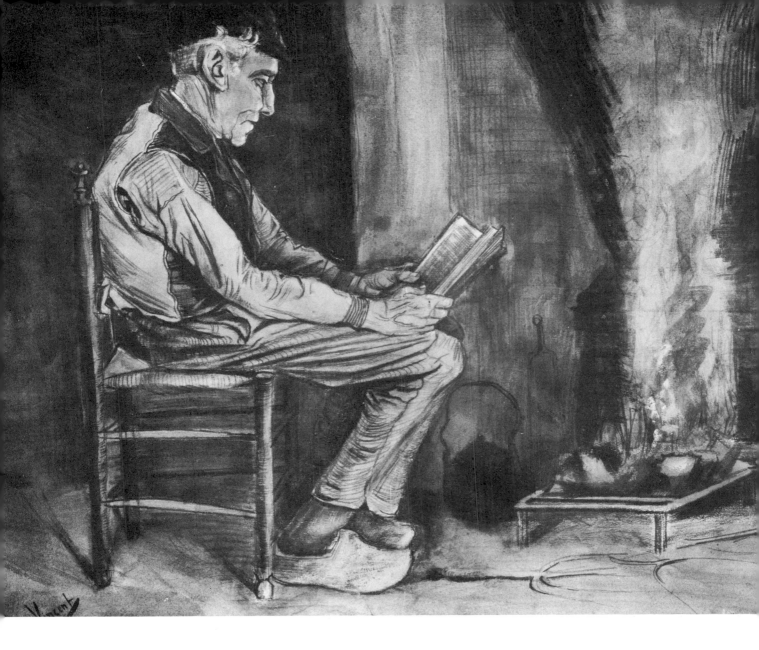

PEASANT READING BY HEARTH 1881

Collection State Museum Kröller-Müller, Otterlo, Holland

Vincent went to the city of the Hague and called at the studio of his cousin, Anton Mauve. Mauve, who was a successful artist, received his young cousin cordially. He gave him a paintbox and showed him how to hold his palette. He helped him find a studio and when he learned that Vincent slept on the floor, he loaned him money to buy a bed.

From his studio window Vincent sketched a carpenter's workshop and laundry. He made drawings of the canals and the city streets. Theo sent him money every month, but after he had bought paper and ink he never had enough for food. Often he went days without anything to eat, but he suffered most when he had no money for sketchbooks and pencils. Only by learning to draw would he be able to pay his debt to Theo.

One March day an art dealer called at his studio. He liked Vincent's drawing of a canal and asked the young artist to make him twelve sketches of city scenes.

"Theo, it is miraculous!" Vincent wrote. But would the art dealer like his drawings, he wondered. For days he sketched dingy tenements and grim factories which were just outside the city. He was not interested in the historical monuments of the Hague. When the art dealer saw the finished sketches he was far from pleased. Vincent was never able to sell him another drawing.

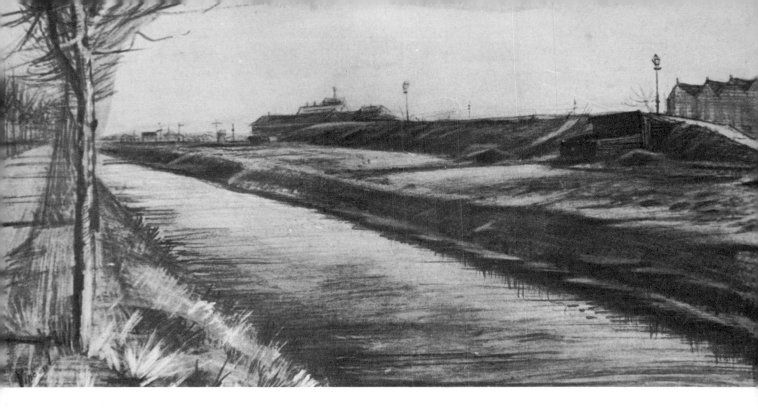

CANAL AT THE HAGUE 1882

Collection State Museum Kröller-Müller Otterlo, Holland

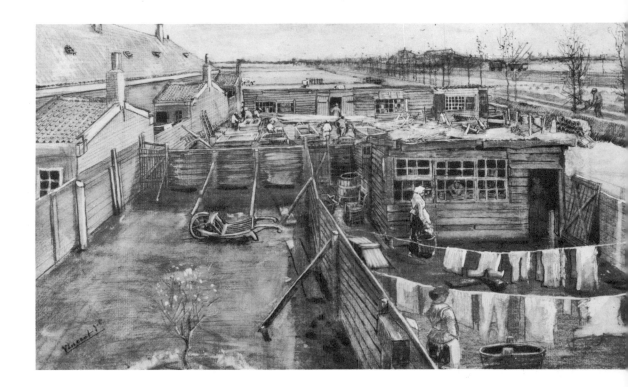

CARPENTER'S WORKSHOP AND LAUNDRY 1882

Collection State Museum Kröller-Müller, Otterlo, Holland

"People who know me consider me a failure," Vincent wrote to his brother. Even his friends avoided the strange, red-haired artist who lived on his brother's money and drew ugly pictures of poor people.

He spent many hours sketching worn men and women in the poor-houses, because he saw great beauty in their old faces. He drew ragged women who were emptying ash bins in gloomy garbage sheds. He saw men filling sacks of coal by the railroad station and told Theo that "the sight was splendid." One day he drew an old man sitting with his head in his hands. "How beautiful is such a workman!" he exclaimed.

"I have found a work that gives inspiration and zest to life," Vincent wrote; but as soon as he stopped his work he became lonely and depressed. He worried that he was a burden to his brother. His stomach ached and his eyes watered.

"Life has then the color of dishwater," he told Theo. "On such days one would like to have the company of a friend."

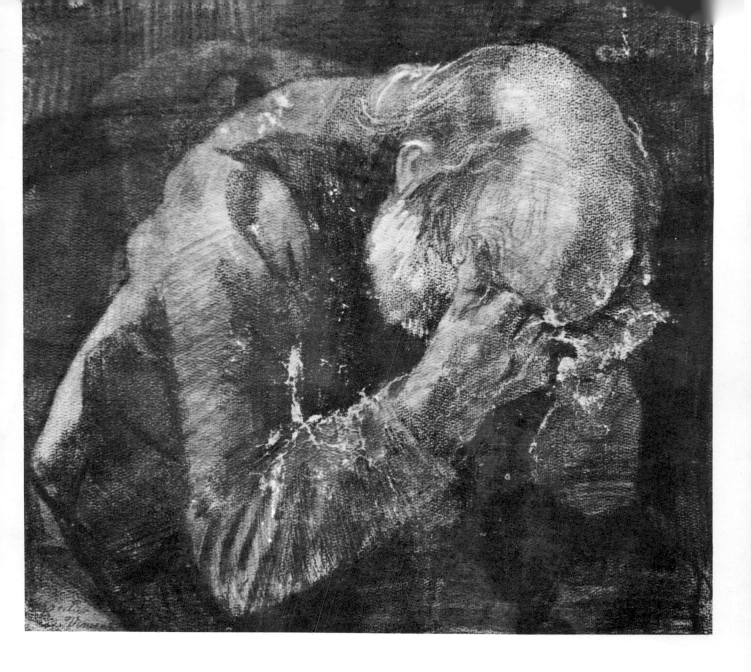

OLD MAN WITH BOWED HEAD 1882
Collection State Museum Kröller-Müller, Otterlo, Holland

Vincent found a friend at the Hague, a poor, rough-mannered woman, whose name was Christine. She and her little girl were hungry and homeless. He took them into his studio and shared his food with them. Christine cooked his meals and kept the studio neat and clean. When Vincent needed models, she and her little girl posed for him. He told Theo that he planned to marry this woman who had made a home for him, and his brother sent more money so that he could rent a larger studio. But the people of the Hague were shocked that Vincent gave the coarse, ill-mannered Christine a home. Even his cousin Mauve avoided him.

Vincent worked hard, but no one would buy his pictures. Christine scolded him for spending so-much money on paints instead of food, but she refused to move to the country where living was cheaper. Finally Vincent, worn out with worry and work, could endure the city no longer. In the fall of 1883 he said good-by to Christine and set out for the village of Drenthe.

During the peaceful autumn days he painted happily on the broad moors. It was good to be in the open air again. But when he returned to his room each evening he was overwhelmed with a terrible loneliness. During the dark rainy days of November he sat in his dreary attic room and watched water dripping through the roof into an empty paintbox. He had worked hard for four years. Although he had sold some drawings, he had not sold a single painting. His debt to Theo was enormous. If he could return to his family's home, he would no longer have to accept money from his brother. His parents had moved to the village of Neunen, and Vincent began to imagine the pictures he could paint there of peasants digging potatoes and weavers at their looms. When the December winds began to blow through the cracks in the walls of his room, he decided he would return home for Christmas.

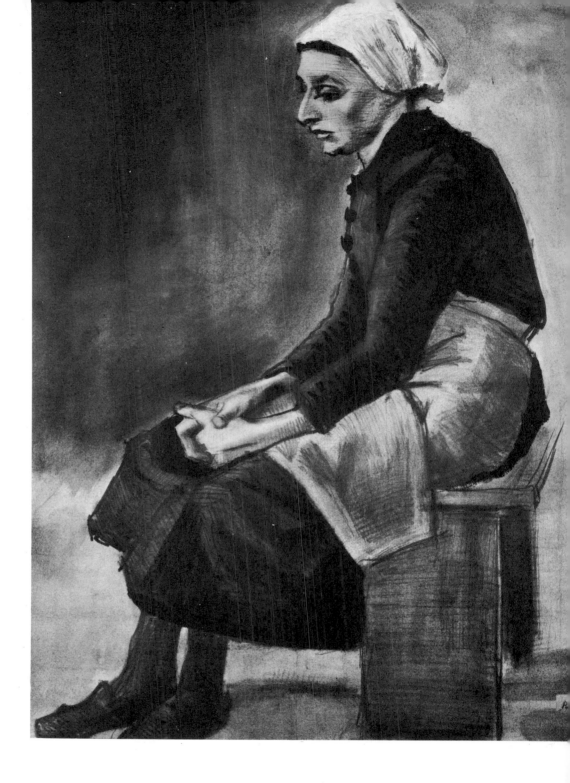

SIEN POSING 1883
Collection State Museum Kröller-Müller, Otterlo, Holland

Vincent was unhappy in the well-ordered home of his parents. His father and mother were kind to him, but he knew he was not welcome. "They feel the same dread about taking me in," he wrote to Theo, "as they would about taking in a big rough dog."

Vincent's manners were crude, his appearance untidy. He walked about Neunen dressed in a dirty blue smock, and a soft-brimmed hat pulled down over his eyes. The respectable citizens avoided him, but he ignored their criticism.

"I often prefer to be with people who do not even know the world," he wrote to Theo, "such as peasants and weavers."

The weavers welcomed the shabby artist into their homes. He would sit huddled in a dark corner and sketch them as they worked. The shadows of the great looms cast exciting patterns against the white walls. He wrote Theo that the weaver looked like "a black ape or gnome" bent over his great oak loom, making "those ribs clatter all day long."

In the daytime, Vincent set up his easel in the laundry and began to paint from his sketches. He worked day and night and his eyes grew red from the strain. He sent his paintings to Theo in Paris, but they did not sell.

"These looms will cost me a lot of hard work," Vincent told his brother, "but they are . . . such splendid things . . . that I certainly believe it is a good thing to have them painted."

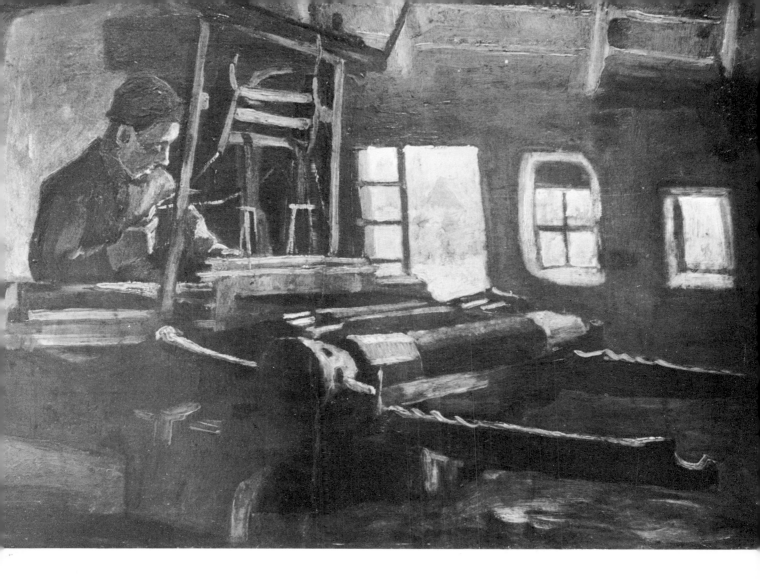

THE LOOM 1884

Collection State Museum Kröller-Müller, Otterlo, Holland

When spring came, Vincent pulled his battered hat over his eyes and walked out into the country where the peasants were plowing in the potato fields. Against the violet haze of the sky the figures stood out boldy, and Vincent tried to draw them as they worked.

Every day he returned to the fields. He walked many miles carrying a heavy paintbox. Sometimes he tramped through thorn bushes which tore his clothes and scratched his legs. Dust blew in his eyes while he painted and the flies swarmed around him. The light changed constantly and the figures never stayed still.

All through that summer Vincent was in the fields with the peasants, painting under the hot sun. "One must paint the peasants as being one of them," he wrote to Theo, "as feeling, thinking as they do."

When fall came, Vincent was ready to paint a finished picture of the potato diggers. "I think I can make something of it," he told Theo.

Most people thought that Vincent's picture, the "Potato Diggers," was crude and unfinished. The figures of the peasants were not well-drawn, but he had painted them with so much feeling that the picture seemed startlingly alive.

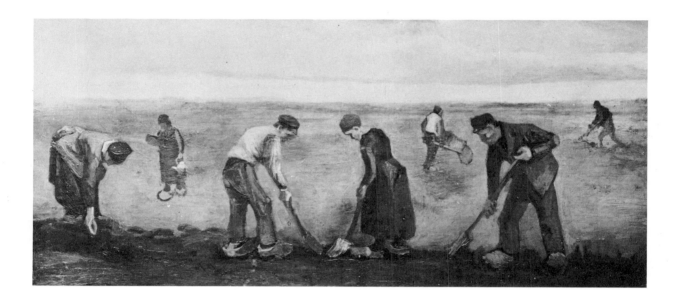

POTATO DIGGERS 1884

Collection State Museum Kröller-Müller, Otterlo, Holland

A family of peasants were gathered around a small table eating their evening meal of potatoes and tea. Vincent sat in a corner of the room and sketched the scene. He planned to make a big painting of the potato eaters to send to Theo for his birthday.

Every evening he took his sketchbook to the peasants' cottage, and every day he made paintings from his drawings. In the laundry he painted fifty heads of the bulbous-nosed, thick-lipped peasants. He painted their knotty hands in a light flesh tone, but the color did not satisfy him. "Peasants' hands should be the color of a good dusty potato," he wrote. So he painted the hands again.

All that winter Vincent worked feverishly, running from the laundry to the cottage to sketch some detail of a head or a hand.

A few days after Theo's birthday, Vincent finished his first big painting. "It will perhaps disappoint you," he wrote to his brother, "But . . . it comes from the heart of the peasants' life . . . I have loved to make it and I have often worked at it with a certain animation."

The "Potato Eaters" was finished in the spring of 1885. In November, Vincent wrote his brother that he had decided to study art in the city of Antwerp. But he did not stay there long. He never had enough money to buy a hot meal. He smoked a pipe in order to forget his pangs of hunger, but smoking made him cough. His teeth began to break off. He looked old and haggard, although he was only thirty-two years old. Theo wrote that he had rented an apartment in Paris and suggested that his brother share it with him. He spoke of a group of painters called the Impressionists, who painted light in small dots of pure color. Vincent longed to see these glowing canvases and meet the artists who painted them.

One day in February, 1886, Theo received a note from his brother. Vincent had arrived in Paris and was waiting for his brother at the Louvre Museum.

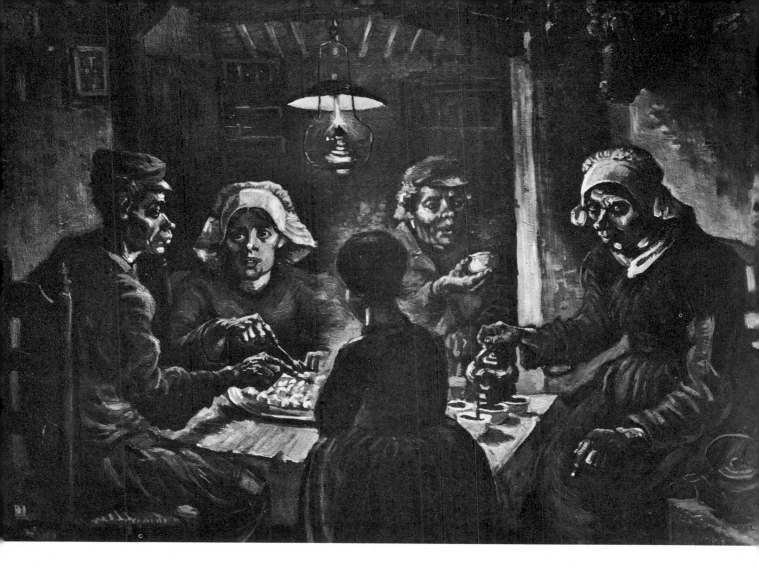

POTATO EATERS 1885
Stedelijk Museum, Amsterdam, Holland

In the art gallery where Theo worked, Vincent saw the paintings of the Impressionists. He was almost dazzled by the bright canvases. For ten years he had painted in tones of brown and gray. Suddenly he began to see everything in clear color.

At the art school where Theo took him, he met young artists who discussed modern art. He made friends with a strange dwarf, who was a brilliant artist. His name was Count Toulouse-Lautrec. He came to know a friendly little man named Bernard, who was a painter and a poet. After school the friends gathered at a restaurant and discussed their ideas on art. Vincent entered into the discussions with passionate enthusiasm, and the other artists grew to like the strange explosive Dutchman.

Vincent tried to copy the style of the Impressionists. He no longer used the dirty tones of the "Potato Eaters." His friends gave him flowers, and he painted them in light clear tones. He could not afford models, but he painted himself over and over again. Sometimes he wore a blue smock which contrasted with his red beard. He made a picture of himself wearing a fur cap, and another in a heavy felt hat. He made twenty-two self portraits, and each one is different. But in all Vincent's paintings of himself there is the same intensity of expression in the deep-set blue eyes which look from under his wide forehead.

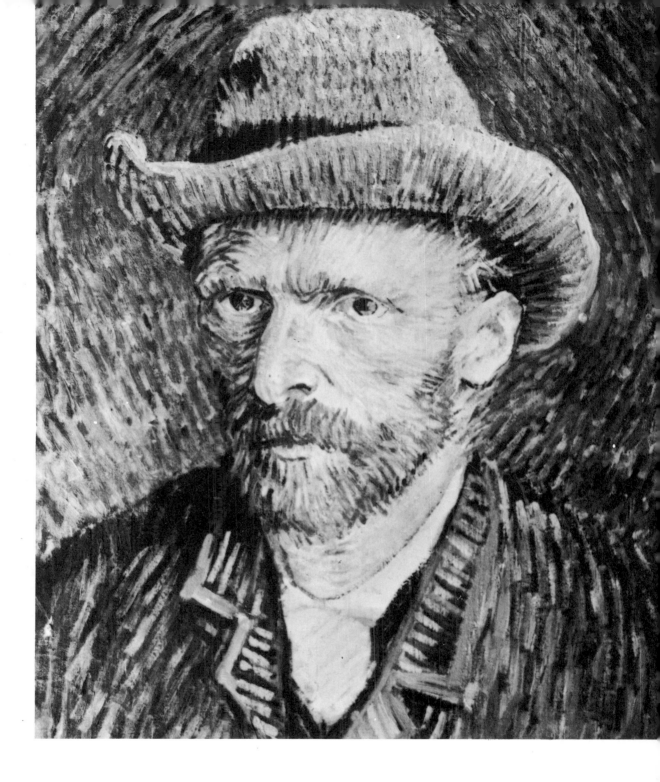

SELF PORTRAIT 1887

Stedelijk Museum, Amsterdam, Holland

Soon after Vincent arrived in Paris, he and Theo moved into an apartment on the rue Lepic.

"We are getting along well in the new flat," Theo wrote his mother. There was a kitchen where the brothers cooked their meals, a homey living room and a small studio for Vincent. While Theo worked at the art gallery, Vincent painted furiously. When the weather was good he worked outdoors, sketching the gardens, the wooden huts and the old windmills which were just outside the city. From his studio window he painted a view of the Paris roofs.

Picture after picture he painted, trying to copy the sparkling style of the Impressionists. When Theo returned home each evening, tired after a long day's work, he found wet canvases on every chair and dirty paintbrushes in the kitchen sink; but he never reproached his brother for his untidiness.

As they ate their supper, Vincent talked excitedly about his plan to found a colony of artists. He wanted Theo to help him buy a house where the young artists could live and paint together. Theo listened and ate.

The rue Lepic became a gathering place for many artists. The dwarfed Toulouse-Lautrec climbed painfully up the stairs almost every evening. Little Bernard came too, and often a loud-voiced, dark-skinned artist with a long nose named Paul Gauguin. Gauguin had been a sailor, then a prosperous stockbroker, until one day he decided to become an artist. He had starved ever since.

Late into the night the artists drank, smoked and talked about painting. Even after his friends had left, Vincent sat on the edge of his brother's bed and poured out his ideas about the art colony. Wearily the sleepy Theo consented to help him with his plan. Although not one of Vincent's paintings had been sold, Theo gave unselfishly of his time and money, for he believed that Vincent van Gogh had the genius of a truly great artist.

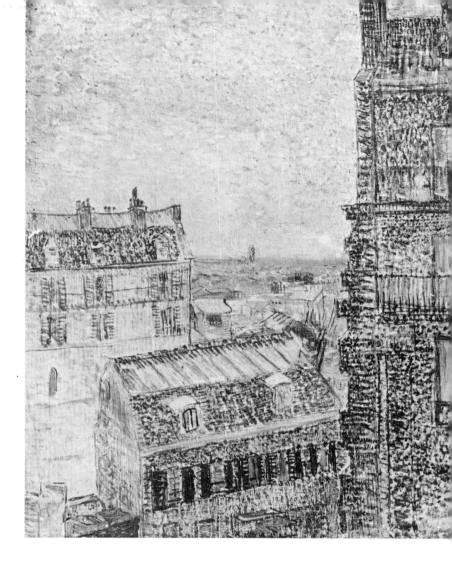

VIEW FROM VAN GOGH'S STUDIO, RUE LEPIC 1887
Stedelijk Museum, Amsterdam, Holland

One of Vincent's best friends in Paris was a kind little man named Tanguy, who sold paints and canvases in a tiny shop near the rue Lepic. He liked artists and often loaned them paints in exchange for pictures. The grateful artists called him "father," or Père Tanguy. Vincent used to spend many hours studying the Japanese prints which Père Tanguy kept in the back of his shop. The flat, clear colors and simple designs fascinated him.

Tanguy liked Vincent. Many times he loaned him paints and once, when his ill-humored wife wasn't looking, he put one of Vincent's paintings in his window.

Vincent loved Père Tanguy's honest peasant face and he painted it three times. One portrait was finished in a single sitting. He placed the square figure with folded hands in the center of the picture against a background of bright Japanese prints. There is great life in the homely face, which is painted in little strokes of many colors. From the Impressionists, Vincent had learned to put light in his pictures. The browns and grays of the "Potato Eaters" had vanished from his palette forever.

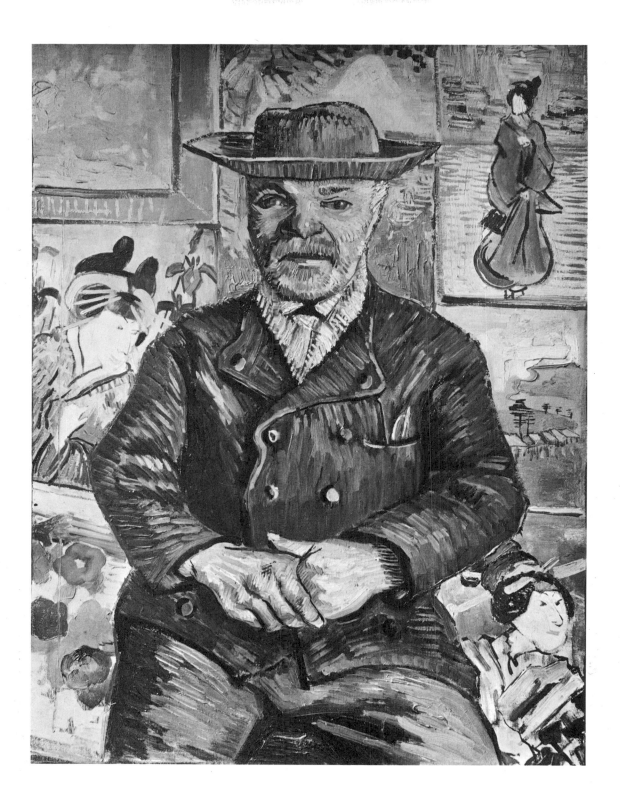

PÈRE TANGUY 1887

Collection Edward G. Robinson, Beverly Hills, California

Photo Courtesy of Wildenstein and Co., Inc.

Vincent often met his friends at a little restaurant called the Café Tambourin. The owner was a strange looking, black-haired woman whom the artists called La Tambourin. She liked Vincent and allowed him to pay for his meals with paintings. She gave him permission to hang Japanese prints on the walls of the restaurant, and it was against this background that he painted La Tambourin's portrait. Arms folded, she sits at a drum-shaped table, her parasol on the stool beside her.

One day Vincent took down the Japanese prints and he and his friends decorated the walls with their startling canvases. In this way, Vincent believed, the working people of Paris could learn about modern art. The young artists waited anxiously for their paintings to sell. Toulouse-Lautrec, Bernard and Gauguin each sold at least one painting. Vincent sold nothing.

Some months later the Café Tambourin went bankrupt. La Tambourin closed its doors and refused to give back the paintings which were left. Enraged, Vincent pushed a cart to the restaurant door, loaded it with pictures and wheeled it through the winding streets of Paris to the rue Lepic. Vincent's idea of bringing art to the people had failed.

Winter came, and Paris grew dark and gloomy. A friend had told him about a town in the south of France called Arles, where the sun shone brilliantly and living was cheap. So, one February day in 1888, Vincent decided to leave Paris.

For the first time since he had lived with his brother, he swept and scrubbed the apartment. He hung his paintings on the walls for he wanted Theo to feel he was still there. He wrote a note to his brother.

"I should like above all to be less of a burden to you," it said.

Then he pulled his fur cap over his red hair, took a last look at the apartment and closed the door behind him. A little later he boarded the train for Arles. Vincent was on his way south in search of a stronger sun.

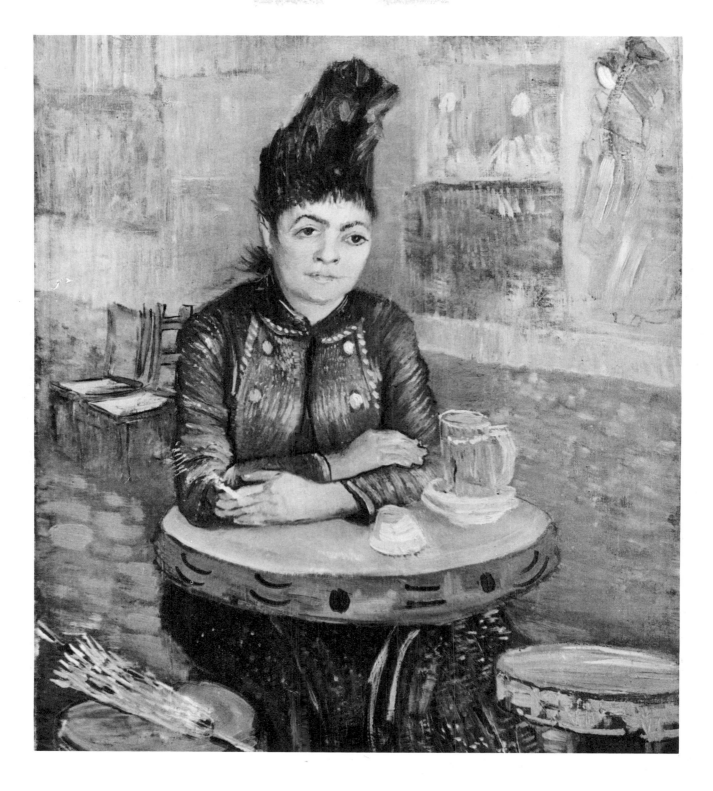

WOMAN IN CAFE TAMBOURIN 1887

Stedelijk Museum, Amsterdam, Holland

The streets of Arles were covered with snow when Vincent stepped from the train, but the sun shone in a hard blue sky. He rented a small room above the café where he had eaten lunch. After he had paid his landlord a week's rent, he rushed out to look at the town. He wandered into the country where the orchards were bursting into bloom. The almond trees "are an intoxicating vision," he wrote to Theo. He brought a branch of blossoms to his room and painted a picture of it in a vase.

One day he set up his easel in an orchard of plum trees. A gust of wind stirred the blossoms and made the little white flowers sparkle. He painted like a man possessed, covering his canvases with thick dots of pure bright color. Every day he returned to the orchards. He painted a blossoming pear tree, glistening white against a violet earth and a very blue sky.

"I am using a tremendous lot of colors and canvases," he wrote to Theo, "but I hope it isn't a waste of money. I want to paint an . . . orchard of astounding gayety."

One evening he returned to his little room and found a letter from Holland telling him of the death of his cousin Mauve, the artist who had taught him how to hold his palette and mix his colors. Against the wall of his tiny room stood the picture he had just painted of two rose-colored peach trees against a bright blue sky. He picked up his brush and wrote in the corner of the picture, "Souvenir de Mauve." Then he signed his name. He would send the painting to his cousin's widow, because, as he wrote to Theo, "Everything in memory of Mauve should be tender and gay."

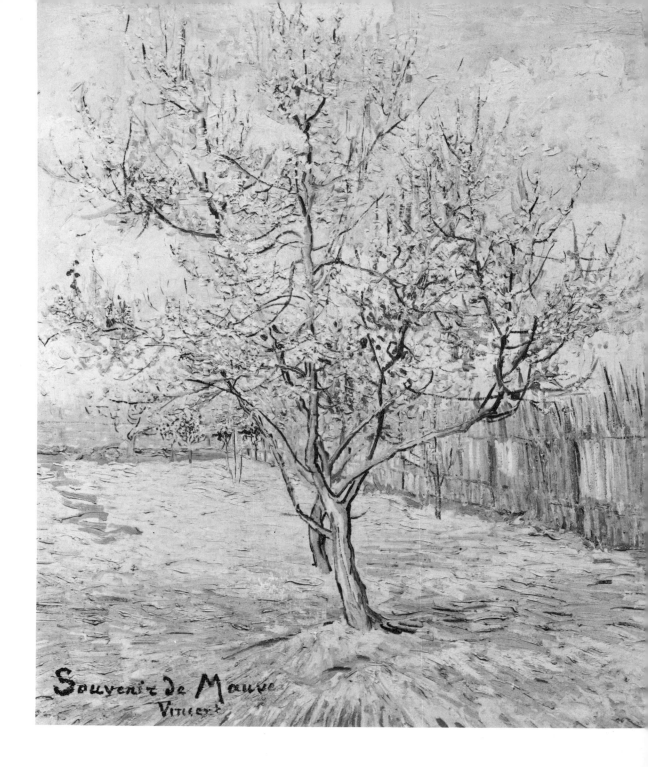

ORCHARD 1888

Collection State Museum Kröller-Müller, Otterlo, Holland

Vincent painted madly in the shimmering light of the fruit orchards, but soon the starry blossoms began to drop. The bright sun grew hotter and melted the snow. "There is sulphur yellow, everywhere the sun lights," he wrote.

He set up his easel on the bank of a river and painted a little drawbridge against a bright blue sky. The scene delighted him because it reminded him of a Japanese print. Again and again he returned to the riverbank. Over and over he painted the drawbridge.

A group of women often washed their clothes in the river by the bridge. Vincent made a picture of them in their bright-colored caps as they knelt on the orange and green bank. Once a little yellow wagon with a white canvas top rumbled across the bridge. Vincent painted it, outlined against the blue sky. He continued to work on the picture when he returned to his room in the evening. He would frame it in blue and gold, he told Theo, and send it to an art dealer in Holland. ". . . It is getting along well," he wrote.

These were happy days for Vincent. His tiny room above the café was bright with sunny canvases. "I can assure you," he wrote to his brother, "the work I'm doing here is better than . . . last spring."

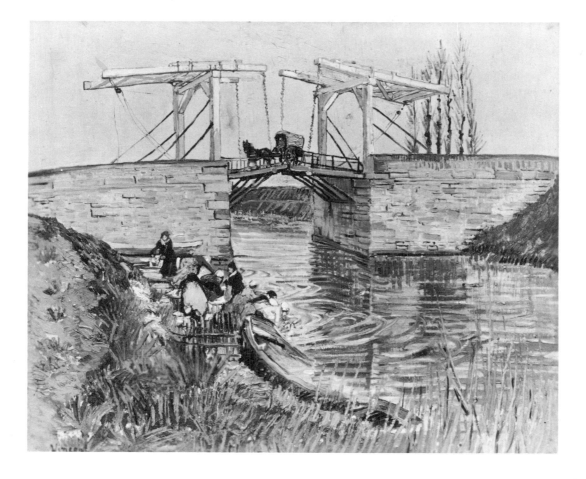

BRIDGE AT ARLES 1888
Collection State Museum Kröller-Müller, Otterlo, Holland

In June the peasants cut the hay and piled it in high round stacks. Vincent painted the mounds, bright yellow against the green grass. The houses in the distance were yellow, too, with bright green blinds. Each evening he brought home a picture which flooded his little room with yellow sunlight.

He wrote Theo that he planned to paint some pictures of the sea, blue and green, to contrast with his yellow paintings. The Mediterranean Sea was only a few miles from Arles, so early one morning he packed his paints and canvases and stepped into a stagecoach. He peered happily from the window as the coach rumbled across bright green plains where little white horses ran wild.

A few hours later he was standing on a broad beach, looking out at the sparkling Mediterranean.

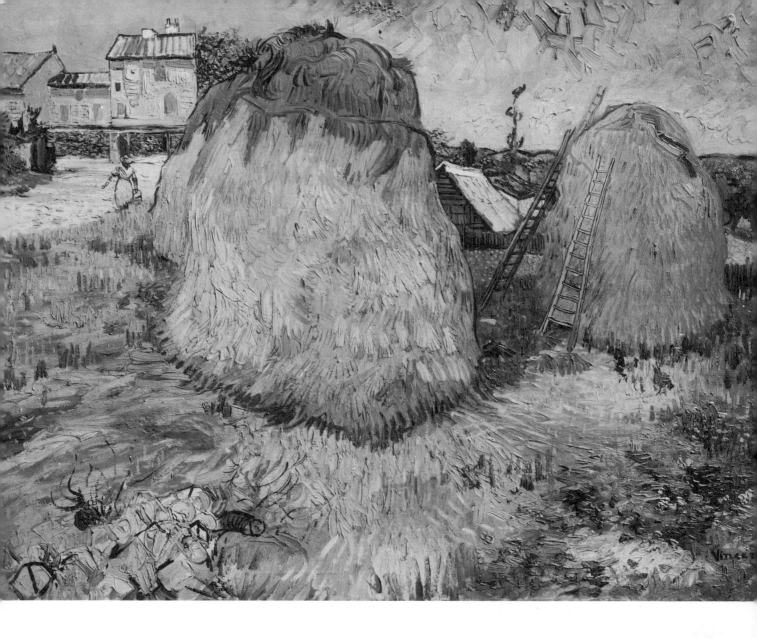

HAYSTACKS IN PROVENCE 1888

Collection State Museum Kröller-Müller, Otterlo, Holland

Vincent was almost dazzled by the changing colors of the Mediterranean. Was the sea green or violet, he wondered, as he squeezed out tubes of pure color on his palette. Suddenly the clouds shifted and the ocean looked rose and gray. On the horizon the sails of fishing boats made tiny white dots against the blue sky.

He stayed in the little fishing village by the Mediterranean for a week and painted every day in the narrow streets or on the wide yellow beach. At night he walked alone on the sand under a starry sky. "The stars were sparkling, greenish, yellow, white rose," he wrote to Theo, "brighter—flashing more like jewels than they do even in Paris."

On the day he planned to return to Arles, Vincent got up very early in order to take his last look at the sea. Drawn up on the beach was a row of little red, blue and green fishing boats. "So beautiful in color and shape," he wrote, "that they made you think of flowers." With quick sure strokes of his pen he made a beautiful drawing of the little boats. It took him just one hour to finish the sketch. Then he returned by stagecoach to Arles.

Some days later he made a painting of the gay fishing boats and sent it to Theo with a letter. He never could have worked so quickly or so well in Paris, he said. That is why he must always live in the south where the brilliant sun made his mind clear, and he could pile exaggerated color on his canvases.

"The painter of the future will be such a colorist *as has never yet been*," he wrote.

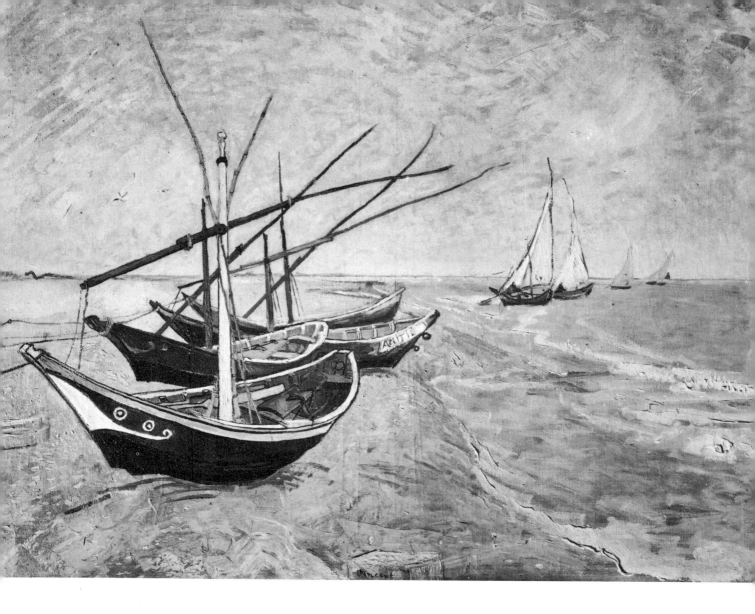

SAILING BOATS AT LES SAINTES MARIES 1888
Stedelijk Museum, Amsterdam, Holland

"Oh, the beautiful sun of midsummer!" Vincent wrote. "It beats on my head and I do not doubt that it makes me a little queer!" Through July he stood bareheaded under the hot sun, painting the yellow wheat fields. In August, he bought a big straw hat. Early each morning he strapped his easel on his back and trudged along a dusty road on his way to the wheat fields. Like the peasants who were cutting the wheat, he worked silently all day under a blazing sun. The mosquitoes stung his face and hands, great green and gold flies swarmed around his canvas, and the wind blew dust in his eyes. He attacked his work violently, never thinking of a single rule.

"I can't tell if I shall ever paint pictures that are peaceful and quietly worked out," he told Theo.

When he returned to his little room at night he was too exhausted to see any good in his paintings. In despair he wrote his brother, "I do not think my pictures are worthy of your kindness to me. . . . It has cost you fifteen thousand francs which you have advanced me . . . (but) . . . we have gone too far to turn back."

Vincent was often too tired to eat dinner at night. At these times only a smoke and a strong drink would revive him. He spent many evenings in the café under his room, and it was here he met the kindly postman, Roulin, who became one of the best friends Vincent ever had.

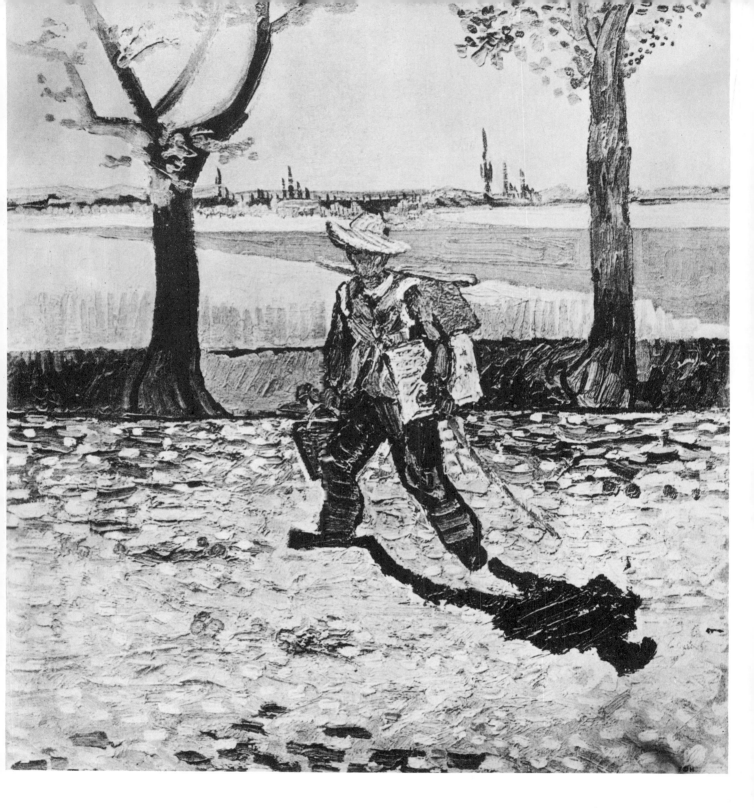

PAINTER ON HIS WAY TO WORK 1888

Kaiser-Friedrich Museum, Magdeburg, Germany

Photo Courtesy of Phaidon Press, Ltd., London

Vincent painted two portraits of his friend Roulin. The postman posed in his dark blue uniform trimmed with gold. His honest face was framed by an enormous square beard. He reminded Vincent of his old friend Tanguy in Paris.

The postman enjoyed posing and refused to accept any money. Instead Vincent bought him dinner and drinks at the café. Roulin became very fond of him.

"Although . . . (Roulin) . . . is not quite old enough to be like a father to me," Vincent wrote, "he has all the same silent gravity and tenderness for me that an old soldier might have for a young one."

The young painter, in turn, had a deep affection for his kind old friend. "A good soul," he wrote, "so wise and so full of feeling and so trustful." And it is this feeling which he expresses strikingly in his portrait of the postman Roulin.

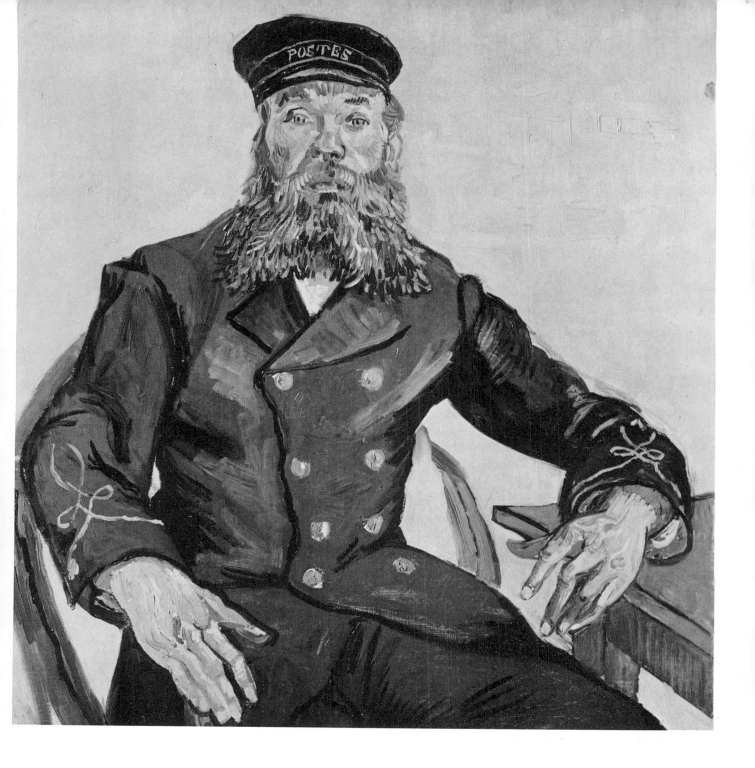

POSTMAN ROULIN 1888

Museum of Fine Arts, Boston

"I've rented a house," Vincent wrote, "painted yellow outside, whitewashed inside and full of sunshine." On the ground floor was a studio with gleaming white walls and a red-tiled floor. Upstairs were two bedrooms, one for Vincent and another for guests. Now he could invite the sick and penniless Gauguin to visit him. He would ask little Bernard to come too. The yellow house would be a home for his young artist friends, a "little retreat for the poor cab horses of Paris," he told Theo.

The yellow house stood on the corner of the Place Lamartine in Arles. Vincent painted a picture of it to send to his brother. On the left was a pink restaurant with violet shutters, where Vincent and Roulin used to eat their dinner. On the right at the end of the street between the two railroad bridges was the home of the postman and his family.

In March, Vincent moved his paints and canvases into the studio. He decorated the walls with Japanese prints, but the other rooms were empty, for he had no money to buy furniture.

"Look here," he wrote to Theo, "as soon as you can, will you not lend me for a year, three hundred francs at one sweep?" He wanted "two decent beds," he said. "That would mean that I could sleep at home. How I would like to settle down and have a home!"

But Theo could not send the money immediately, so Vincent slept at a hotel and painted all day in his red-tiled studio.

"I am thinking of decorating my studio with half a dozen pictures of SUNFLOWERS," he wrote to Bernard. In August, Theo sent him money to buy paints and canvases for his flower paintings. He brought the large yellow blossoms into the house, and, in a fury of enthusiasm, started to work.

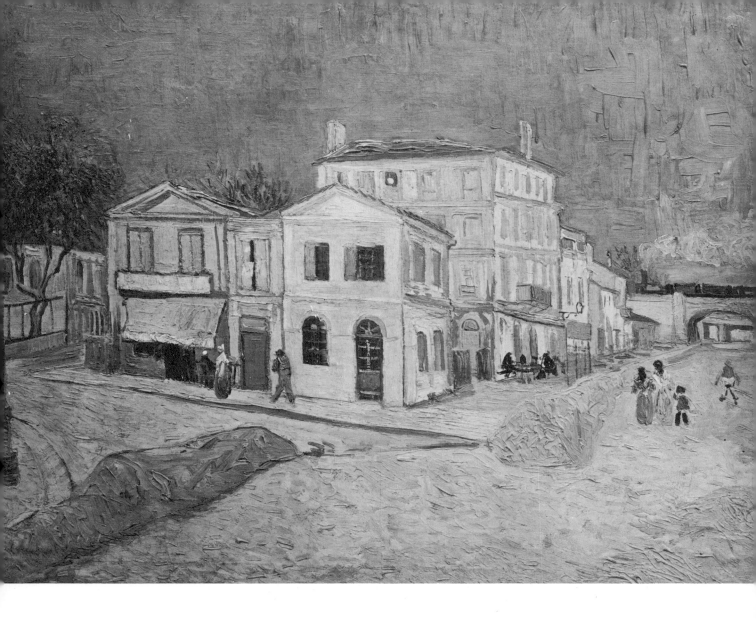

VAN GOGH'S HOUSE AT ARLES 1888
Stedelijk Museum, Amsterdam, Holland

Vincent got up early every morning to paint the yellow sunflowers before they began to fade. First he painted them in a green vase against a light background. The second time the background was deep blue. Then he put the huge blossoms in a bulging earthenware vase and placed them against a background of lemon yellow.

"This last . . . I hope will be the best," he wrote to Theo. The great yellow blossoms shone with the warmth and brilliance of the glorious southern sun, and the paintings lit the room like the stained glass windows of a church. "(They) take on a richness the longer you look at (them)," he told Theo.

To Bernard he wrote, "I seek consolation by looking at the sunflowers," for Vincent had always believed that flowers had a soul.

"The sunflower," he wrote, "is mine in a way."

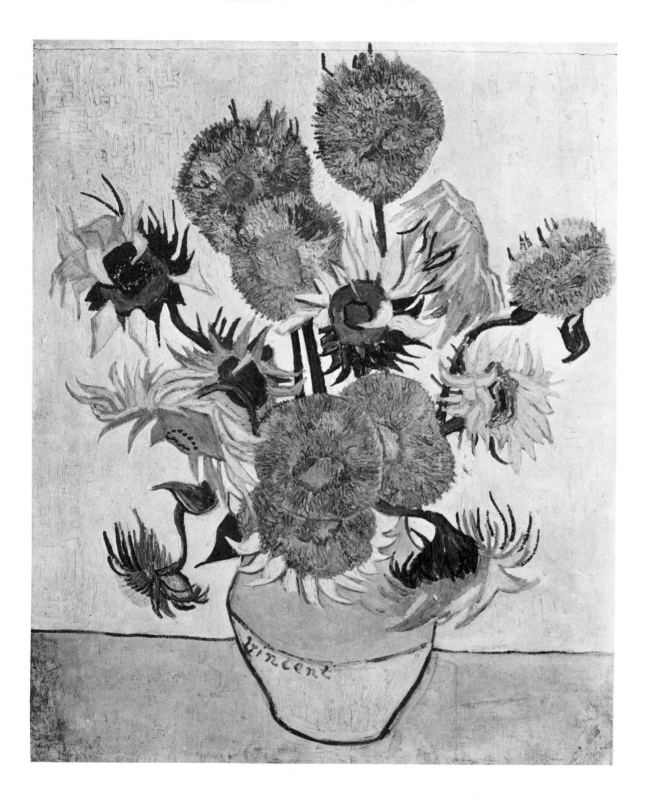

SUNFLOWERS 1888
Stedelijk Museum, Amsterdam, Holland

"I have a model at last," Vincent wrote. He was a dark-skinned soldier, who wore the bright-colored uniform of the French North African troops. He was called a Zouave.

"(He has) the neck of a bull and the eye of a tiger," Vincent said.

Vincent painted the black-haired soldier sitting on a stool in a corner of the white-walled studio. His full trousers, which hang in big folds over his wide spread knees, make a bold splash of brilliant red. His blue jacket is trimmed with red and gold braid, and a bright red cap with a blue tassel sits on the side of his head.

"It's a savage combination of tones . . ." Vincent wrote, "not easy to manage . . . but all the same I should like always to be working on common, even loud portraits like this."

He squeezed out whole tubes of red and blue paint and covered the canvas with big areas of pure color.

"The figures I do almost always seems to me horrid," he told Bernard. But Vincent loved people and painted them as he saw them.

"It is the study of figures," he wrote, "which is the most stimulating, if one sets about it in a different way."

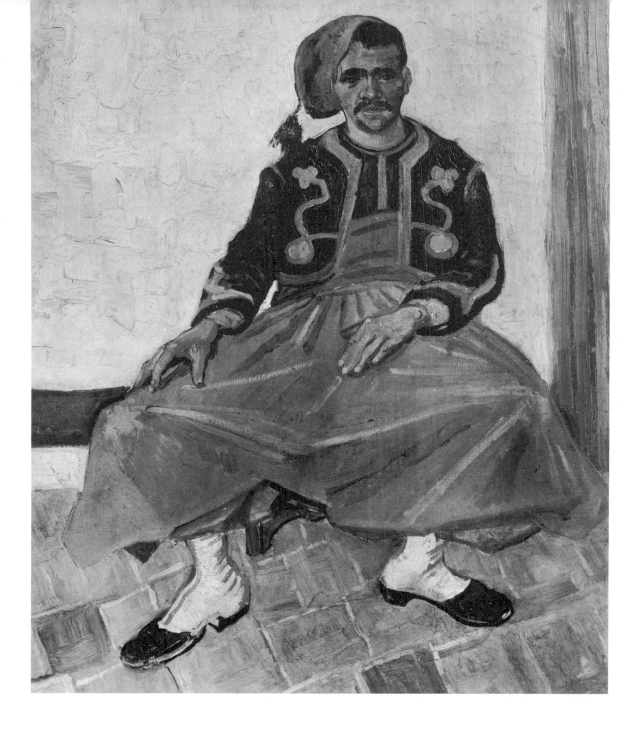

THE ZOUAVE 1888

Collection Mrs. Albert D. Lasker, New York City

Not far from the yellow house was the small hotel where Vincent slept. Often he did not have enough money to pay the weekly rent, so he suggested to the owner that he paint pictures of the hotel in exchange for his room.

On the ground floor of the little hotel was a café which stayed open all night. Poor people who had no home often slept in this room, slumped over the bare wooden tables.

"The café is a place when one can ruin oneself, run mad or commit a crime," Vincent wrote, and it was this feeling he tried to express in his painting, "Night Café."

"It is one of the ugliest pictures I have ever done," he said. A savage lemon yellow light from four hanging lamps shines down on a green-topped billiard table. The hair of the white-coated owner is green, too, and the walls of the room are a bright red. The clock above the door reads fifteen minutes past midnight. Three men are sleeping at the tables by the wall, their heads buried in their arms.

Vincent painted in the dreary lonely room for three nights, and he slept during the day. He knew that he would never sell the picture, for, he told Theo, "The public likes only pretty things."

The "Night Café" is a disturbing painting. Vincent wrote, "I have tried to express, as it were, the powers of darkness in a low wine shop, and all this in an atmosphere like a devil's furnace of pale sulphur."

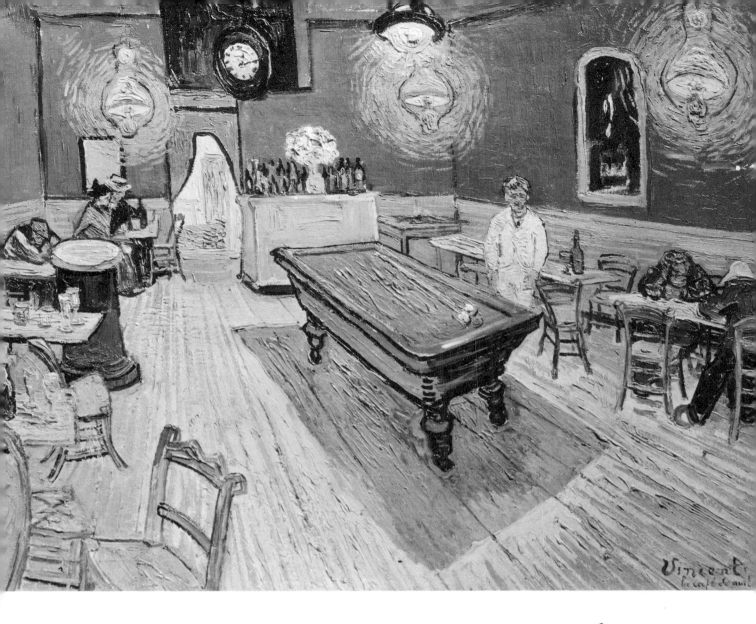

THE NIGHT CAFE 1888

Collection Stephen C. Clark, New York City

"I have had a very thin time of it these days," Vincent wrote in September, 1888. "I have done absolutely nothing but paint and sleep." He lived on bread and coffee for four days. When money came from Theo, he rushed out and bought frames for his pictures. He decorated the walls of the yellow house with his brilliant paintings, but the rooms were still unfurnished.

One September day the postman Roulin handed him a letter from Paris. Enclosed were three hundred francs. Theo had inherited money and he wanted his brother to buy furniture for his home. Roulin and his good wife helped Vincent select two beds; a fine walnut one for the guest room and a small unpainted one for himself. He bought a mirror so that he could paint his own portrait, twelve yellow chairs and some pots and pans for the kitchen. In a few days the money had disappeared, but a happy Vincent moved into the house on the Place Lamartine.

"I have such joy in the house," he wrote, "that I dare even think that the joy will not always be solitary." He sent a long letter to Gauguin inviting him to Arles.

"If he came," Vincent told Theo, "there would be no lack of ideas." He longed to discuss his paintings with another artist. "I am conceited enough to believe that I shall make a certain impression on Gauguin with my work," he wrote, and began to paint with furious energy.

Because the October wind blew so fiercely he worked indoors. He made a gay picture of his bedroom to send to his brother. There is a blood-red quilt on the yellow bed; on the orange dressing table is a bright blue basin and pitcher. The chairs are yellow and the floor a dull red.

On the twenty-third of October, Theo wrote his brother that he had sold one of Gauguin's paintings. At last the penniless painter would be able to buy a ticket to the south of France. Vincent was elated.

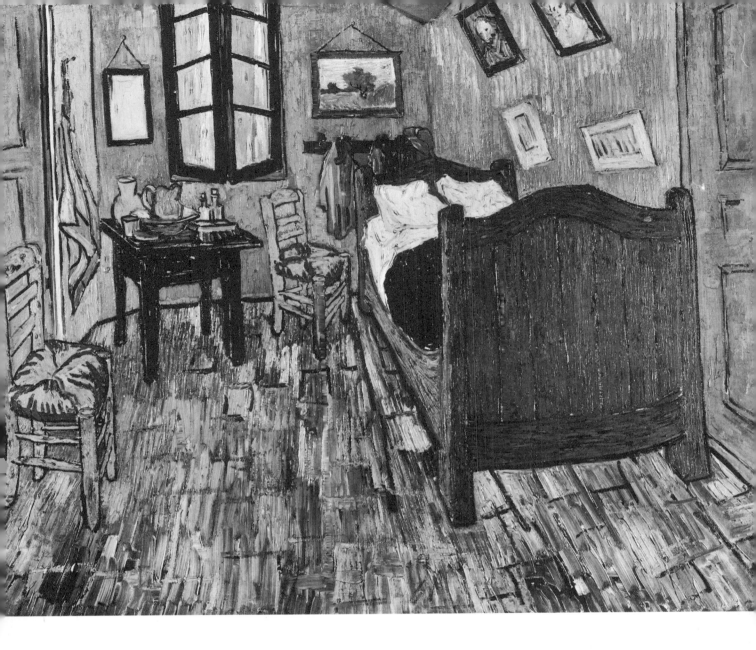

VAN GOGH'S BEDROOM AT ARLES 1888
Courtesy of The Art Institute of Chicago

Early one morning Gauguin knocked at the door of the yellow house. Vincent welcomed him enthusiastically, rushing from room to room in his eagerness to have his friend see his home and his paintings. Gauguin said little about the sunny landscapes, but he was entranced by the sunflower paintings. Hurriedly he unpacked his bags, for Vincent was anxious to show him the sights of Arles.

As the two artists walked through the town, Gauguin admired the handsome dark-haired girls who passed him in the street. He thought the scenery around Arles was magnificent, and he wanted to start painting immediately. When they returned home that evening, Vincent, like a volcano, began to pour out his ideas on art. Gauguin disagreed violently, and the artists argued hotly until late at night. Early the next morning they started to work.

Vincent was happy to have another painter living and working in the yellow house. "He is a very great artist and an intelligent friend," he wrote to Theo. "I must also inform you that he is an excellent cook."

Gauguin made a portrait of Vincent as he sat painting his beloved sunflowers. "Yes, it is me," Vincent said when the picture was finished, "but as if I was crazy."

One day a dark-haired woman with strong features posed for the artists. She wore the black dress and small black cap of the women of Arles.

"I have found an Arlesienne at last," Vincent wrote. Her name was Madame Ginoux. In an hour he slashed the figure on the canvas against a background of pure yellow.

"The face gray, the clothes black, black, black, with perfectly raw Prussian blue." The picture was as bold and flat as a Japanese print. Vincent's picture of the Arlesienne is one of the most striking portraits he ever painted.

THE ARLESIENNE (MADAME GINOUX) 1888
Metropolitan Museum of Art, New York City

Good Madame Roulin, the postman's wife, was a kind motherly woman who welcomed Vincent into her home. He painted her portrait four times as she sat rocking the baby's cradle. She reminded him of a legend about French sailors which Gauguin had once told him. The sailors used to tell of a woman who appeared in their boat during a storm at sea and sang a lullaby as the waves tossed the ship. The sailors, believing it was a mother rocking them to sleep, were no longer afraid.

Vincent painted "the cradle woman" for the cabin of some fishing boat, for he wanted the picture to bring comfort to a fisherman as he tossed on a stormy sea.

The good Madame Roulin sits in an armchair, holding the cord which rocks the baby's cradle. Her hair is orange, her dress a strong green, and behind her is a gay wallpaper of huge pink flowers on a green background. The picture is boldly painted in strong colors. Gauguin called it "a horror," but there is a tenderness in the woman's firm face, which expresses the warm feeling Vincent felt for a kind mother who protects her child.

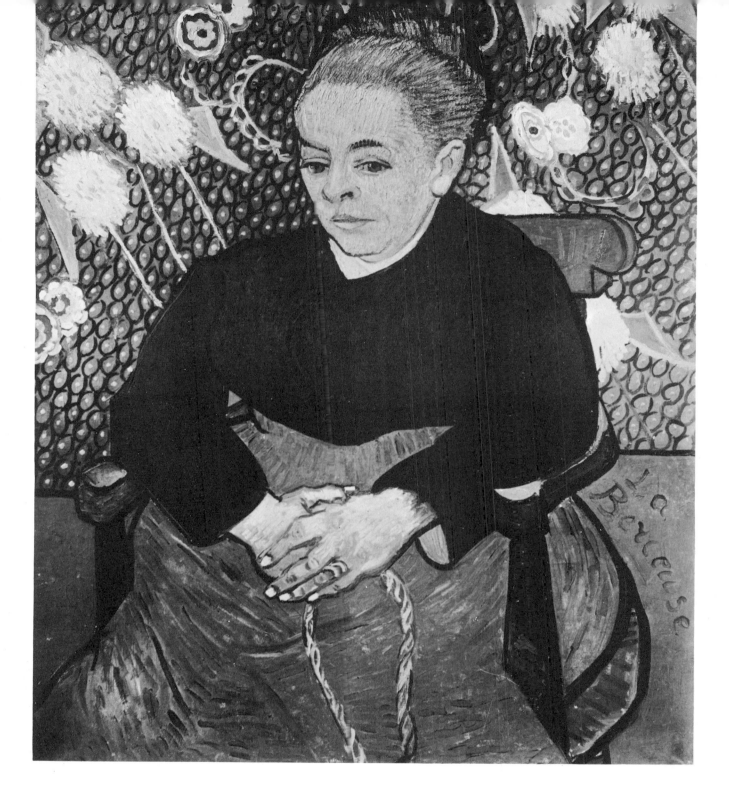

WOMAN ROCKING A CRADLE 1889
Museum of Fine Arts, Boston

"Gauguin and I talk a lot," Vincent wrote. "Our arguments are terribly electric." Although he admired Gauguin greatly, he usually made some criticism of his work which infuriated the older painter. Gauguin made fun of Vincent and told him his taste was atrocious.

One evening as the two artists sat in a café, Vincent became enraged and threw a glass in Gauguin's face. Without saying a word he got up and went home to the yellow house.

"My dear Gauguin," he said the next day, "I have a vague feeling that I insulted you last night."

"I forgive you with all my heart," Gauguin replied, "but yesterday's scene may be repeated . . . so let me write to your brother to tell him I am returning."

That day Vincent followed Gauguin around the house talking excitedly and begging him to stay in Arles. In the evening Gauguin, wanting to be alone, went for a long walk. When he returned to the house he found his friend sleeping peacefully, his head wrapped in a bandage. Vincent had cut off a piece of his ear, wrapped it in paper and taken it to the home of an Arlesienne, saying, "This is a souvenir of me."

After Gauguin had called the doctor, he packed his bags and took the train to Paris.

In a few days, Vincent's ear had healed. He pulled a fur cap over his bandage, put his pipe in his mouth and painted a portrait of himself in the mirror.

Outside the December winds blew furiously. Vincent stayed indoors and made copies of his sunflower paintings. He ate little and drank cup after cup of coffee.

"Often I hardly know what I am doing," he wrote, "working almost as in a trance."

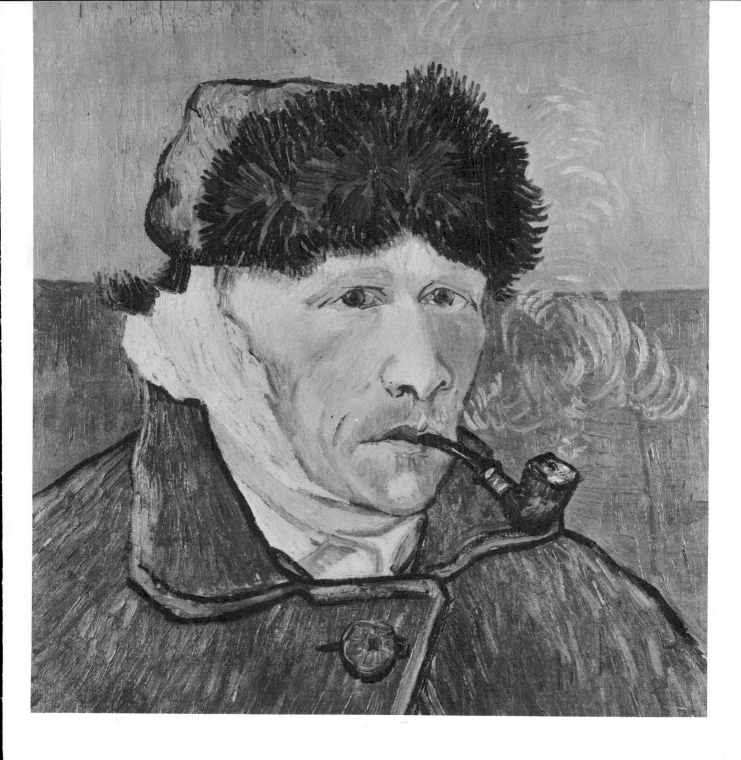

SELF PORTRAIT 1889
Collection Leigh B. Block, Chicago

Courtesy of The Art Institute of Chicago

In January, 1889, Roulin and his family moved to Marseilles. Sadly Vincent bade them good-by at the railroad station. Then he returned to the yellow house and plunged frantically into his work. He made copies of his yellow sunflowers and sulphur-colored wheat fields. He hardly ate at all. When the doctor told him that he drank too much coffee, he replied that it was only in this way that he could "attain a high yellow tone." Furiously he carried on his pursuit of yellow. My "tale of pictures is not yet complete," he wrote to Theo.

Then, one day he was taken to the hospital. The doctor told him he must have a long rest for he was worn out from overwork. Through the early spring he rested peacefully at the hospital of St. Remy. When he felt better the doctor gave him his paints and canvases. From his room he made a picture of green fields and dark blue hills. On warm days he walked out into the shady garden. Some of the patients watched him quietly as he made a beautiful black and white drawing of the big stone fountain. The quiet and rest at St. Remy had brought peace to Vincent's troubled mind. He had given up his mad desire to paint yellow light, and he was happy as long as he was allowed to work.

When June came the doctor told him that he could take his canvas and paints out into the wheat fields.

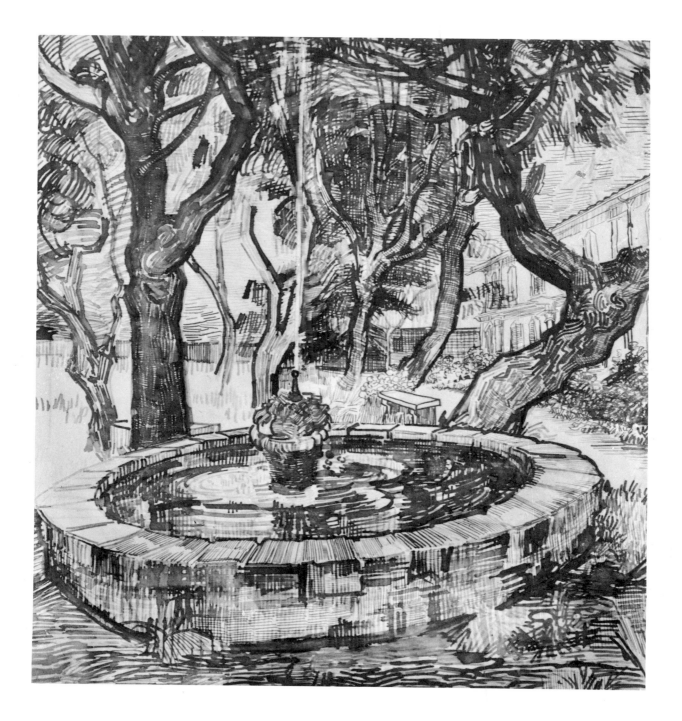

GARDEN AT ST. REMY 1889
Stedelijk Museum, Amsterdam, Holland

"Have you seen a study of mine with a little yellow reaper, a yellow wheat field and a yellow sun? . . . In it I have tackled that devilish problem of yellow again," Vincent wrote.

The humming of the crickets rang in his ears, the yellow sun grew hotter and flooded the whole landscape with a light of pure gold. Vincent worked as if in a dream and he painted the sun itself, blazing in a sulphur sky. One day he dropped to the ground, unconscious, overcome by the intensity of the brilliant light he was trying to paint. When he was brought back to the hospital, his paints were taken away and he was told to rest for a long time.

Through the fall and winter he stayed at St. Remy. His mind and body grew stronger, but he was not allowed to work. He wrote despairing letters to Theo. How would he ever pay his enormous debt to his brother if he could not paint again? After nine years of furious work, he had not sold a single painting.

Then one day a letter came from Paris. Inside were four hundred francs. Theo had sold one of Vincent's paintings! Life seemed less black that day. His first success gave him courage and hope. When spring came the doctor gave him his paints, and he went out into the silver and green olive groves. He sent his pictures to Theo who wrote encouraging letters about his work. A well-known writer had praised Vincent's paintings, he said, and many people had admired his glowing pictures of Arles. But Theo never succeeded in selling another of his brother's paintings.

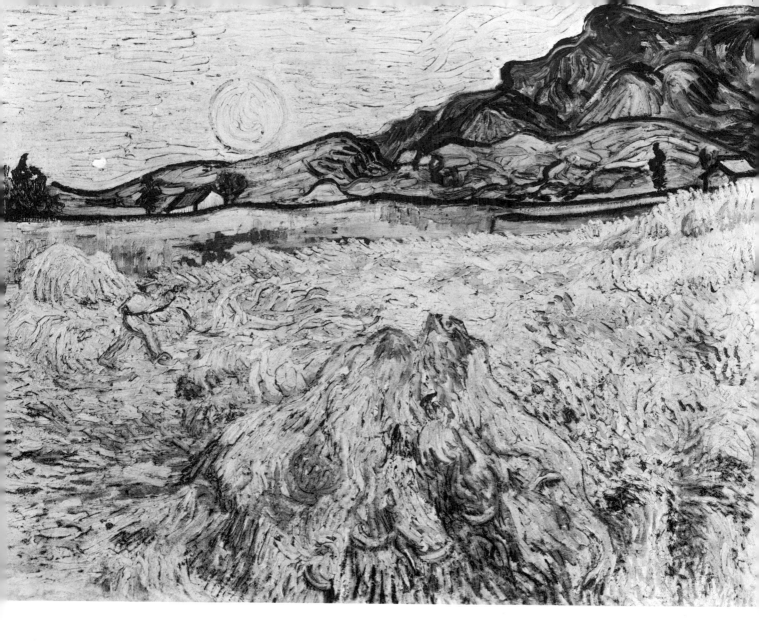

CORNFIELD WITH REAPER 1889

Collection State Museum Kröller-Müller, Otterlo, Holland

Photo Courtesy of Museum of Modern Art

"There are some wonderful nights here," Vincent wrote to Bernard, "I must . . . paint a starry night with cypresses." When he looked from his window before sunrise the stars seemed to shine in swirls of brilliant light, and the cypress trees rose from the ground like dark flames against a deep blue sky. He painted a starry night, working thick layers of paint into twisted, swirling shapes. The tortured curves seemed to express his own restless agony.

Another summer came. Vincent worked in shady ravines where cool streams wound over violet rocks. Sometimes he painted in the streets of Arles, but he was tormented by the people who gathered around him.

Fall came and another winter. The food at St. Remy began to taste moldy. Vincent was tired of living with sick people. In the spring his brother urged him to come to Paris. Theo had been married for over a year and he wanted his brother to meet his wife and see his fine new baby boy, whose name was Vincent. He knew of an excellent Doctor Gachet who lived in the village of Auvers, just outside of Paris. Vincent could live there and spend his days painting in the peaceful countryside.

One day in May, Vincent went back to the yellow house on the Place Lamartine. He packed up the paintings which hung on the walls of every room and shipped them to Theo. A few days later he boarded a train for Paris. From the window he could see the fruit orchards which were bursting into bloom. Vincent was leaving the flowering country of Arles forever.

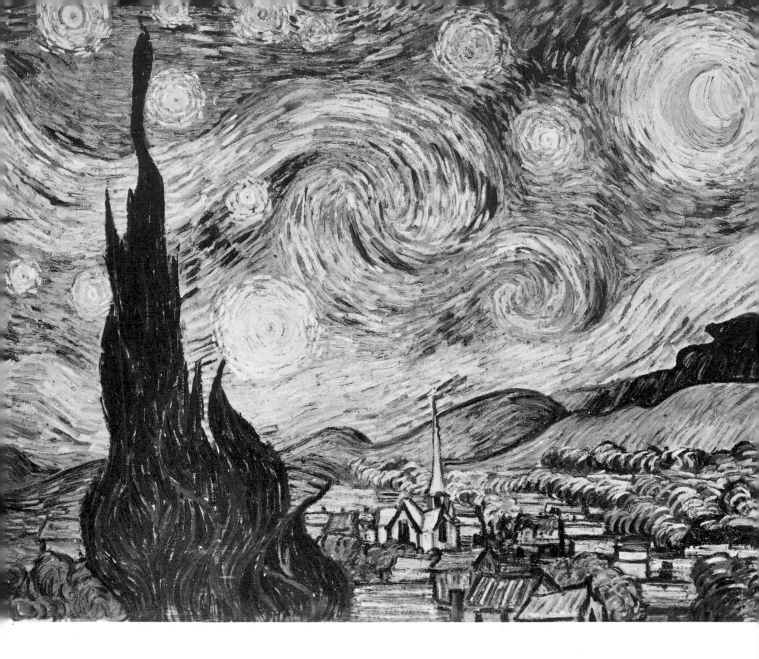

THE STARRY NIGHT 1889
Museum of Modern Art, New York City

Theo was standing on the platform, when the train from Arles steamed into the Paris station. He rushed to greet his brother. Vincent looked well after his long rest at St. Remy, Theo thought. As the brothers rode to Theo's home, Vincent peered excitedly from the window, happy to see the familiar streets of Paris once more.

Theo's wife welcomed her brother-in-law warmly and led him to the room where his little nephew was sleeping. The walls of the room were bright with Vincent's sunny paintings from Arles. The next day Vincent called at the tiny paint shop of his old friend Tanguy. Then he visited an art gallery which was filled with beautiful Japanese prints and he met some of his artist friends at a café; but the noise and bustle of the city tired him. Two days later he took a train to the little village of Auvers where he could live quietly under the care of Dr. Gachet.

Vincent began to draw pictures of the white cottages which lined the streets of Auvers. The thatched roofs which sloped almost to the ground fascinated him. He painted them yellow against a deep blue sky.

Doctor Gachet liked Vincent, and was enthusiastic about his paintings. He invited him to work in his sunny garden which was bright with gay flowers. One day Vincent painted a portrait of the doctor in a blue coat against a light blue background. He rests his elbow on a red table and in front of him is a vase of purple flowers and two bright yellow books.

"Old Gachet is very, yes very, like you and me," Vincent told Theo, for the doctor was discouraged about his job, as Vincent was about his painting. In the tortured, but sympathetic face of his doctor friend he saw "the heart-broken expression of our time."

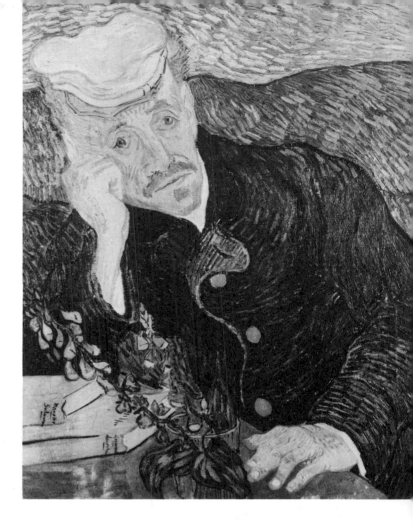

PORTRAIT OF DR. GACHET 1890

Collection Siegfried Kramarsky, New York City

"My steps are wavering," Vincent wrote from Auvers, "(but) I set to work again, the brush almost slipping from my fingers." He made three pictures of "vast expanses of wheat under troubled skies." One July day a flock of crows rose from the golden wheat field and he painted them black against a threatening ash-blue sky.

"I had no difficulty in expressing sadness and extreme loneliness," he wrote. "The prospect is growing dark. I do not see the future in a happy light." Since his illness he had not been able to paint as before. He could not live without help from his brother, and Theo's burden was heavy.

One Sunday in July he returned from the golden wheat field holding his hand to his side. "I could not bear the misery any longer," he told the friend who helped him to his room, "and so I shot myself."

Dr. Gachet put him to bed and dressed his wound. When Theo arrived some hours later, he found his brother sitting in bed calmly smoking his pipe. For two days and nights he sat by Vincent's bedside. The brothers talked of their family and their life in Holland.

"I wish I could go home," Vincent said quietly. A few hours later he died.

Vincent was buried in the little cemetery in Auvers, and Doctor Gachet planted sunflowers around his grave. Six months later Theo died and was placed in the grave beside his beloved brother. "I am the one who wins," Vincent had once told his brother. "You win nothing except the feeling of helping somebody to a career who would otherwise have been without one. . . . I shall always consider that . . . you have your part . . . in my canvases. Who knows," he wrote just before he died, "what we may accomplish together afterwards?"

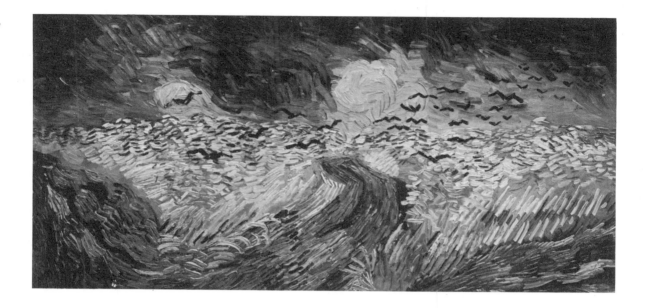

CROWS OVER THE WHEATFIELD 1890
Stedelijk Museum, Amsterdam, Holland

BIBLIOGRAPHY

Barr, Alfred H. Jr.: *Vincent Van Gogh*. The Museum of Modern Art, New York, 1935.

Gauguin, Paula: *My Father*. Alfred A. Knopf, New York, 1937.

Meier-Graefe, Julius: *Vincent Van Gogh*. Harcourt, Brace & Co., New York, 1933.

Meyer-Schapiro: *Vincent Van Gogh*. Harry N. Abrams, New York, 1950.

Museum of Modern Art: *Letters to Emil Bernard*. New York, 1938.

Nordenfalk, Carl: *The Life and Works of Van Gogh*. Philosophical Library, Inc., New York, 1953.

Pach, Walter: *Vincent Van Gogh, 1853-1890*. Art Book Museum, New York, 1936.

Phaidon Press: *Vincent Van Gogh Paintings and Drawings*. Oxford University Press, Inc., New York, 1941.

Phaidon Press: *Vincent Van Gogh in Full Color*. Distributed by Oxford University Press, Inc., New York, 1951.

Stone, Irving: *Dear Theo*. Houghton Mifflin Co., Boston, 1937.

Stone, Irving: *The Lust for Life*. Grosset, Dunlap, New York, 1934.

Terasse, Charles: *Van Gogh*. Librairie Floury, Paris, 1935.

Wight, Frederick S.: *Van Gogh*. Beechurst Press, New York, 1954.